TU Dublin Library

For book return dates:
Use your Student Number &
Library PIN **to access your**
Library account
https://tudublin.ie/library/

Fines are charged for items
returned late

The New West

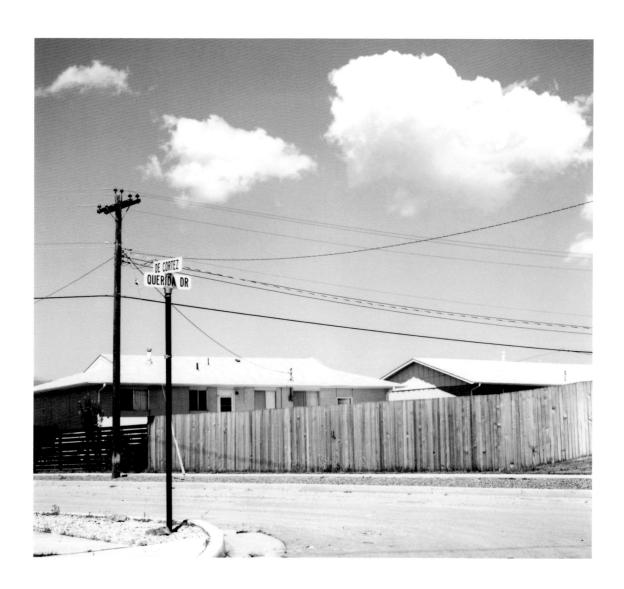

. . . things themselves
 in thoughtless honor
Have kept composure,
 like captives who would not
Talk under torture.

RICHARD WILBUR

THE NEW WEST

Landscapes Along the Colorado Front Range

Written and photographed by Robert Adams

Foreword by John Szarkowski

aperture

Foreword

As Americans we are scarred by the dream of innocence. In our hearts we still believe that the only truly beautiful landscape is an unpeopled one. Unhappily, much in the record of our tenancy of this continent serves to confirm this view. So to wash our eyes of the depressing evidence we have raced deeper and deeper into the wilderness, past the last stage-coach stop and the last motel, to see and claim a section of God's own garden before our fellows arrive to spoil it.

Now however we are beginning to realize that there is no wilderness left. The fact itself is without doubt sad, but the recognition of it is perhaps salutary. As this recognition takes a firmer hold on our consciousness, it may become clear that a generous and accepting attitude toward nature requires that we learn to share the earth not only with ice, dust, mosquitoes, starlings, coyotes, and chicken hawks, but even with other people.

There is considerable evidence to support the view that man is a unique and foreign mutation, an exception, in the otherwise natural and symbiotic life of the planet. Granted, this evidence has been collected and interpreted by men, which suggests that the conclusion might be a perverse sort of bragging. Nevertheless, this view has provided grist for the mills of many of America's most distinguished artists. The most important of these in terms of recent influence is perhaps Thoreau, whose elegantly expressed dyspepsia has convinced many otherwise intransigent rationalists that man is not in fact a part of nature.

Whatever his failings as a naturalist and a philosopher, Thoreau was a very great artist. And, as is well known, the gifts of artists are not really free. Even the gifts of very minor artists are not free. Consider this ad from a photographic trade paper:

NEW BLUE SKIES

If for some reason the sky in your transparency is unsuitable, we can, in most instances, substitute a new blue sky and at the same time remove wires, telephone poles and other objectionable objects appearing in the sky. Charge for this is $20.00.

Not free, but a bargain surely, and a proposition that contains a very imaginative concept: a system for renewing the landscape at the retoucher's table, costing no inconvenient displacement of the world's serious work.

If this is the best we can manage, we should not scorn it, for our best deserves better than easy jokes. On the other hand it is possible that we *might* do better—that we might achieve a landscape that we would find not only good to look at in pictures, but good to fly over, drive past, walk through, and even live in—one that might offer the rewards of recognition and remembrance. Such a place would be a natural landscape with people in it.

This we have considered a contradiction in terms. Since we have understood men to be dangerous at best, and tolerable in the countryside only at very low densities, we have given little serious thought to the proposition that a landscape might be simultaneously beautiful, natural, and populated by human beings. We have instead explored the plausible alternatives.

The most useful of these alternatives has been the idea of segregating the aesthetic and the practical functions of the land. This concept has been pursued in the United States with vigor, intelligence, and considerable success since the administration of U. S. Grant. The concept says in essence that certain especially splendid parts of the natural landscape should be fenced around, in order to keep the citizenry out, or to allow them in as transient visitors, under adequate precautionary controls. This idea has achieved great victories, especially in the case of lands which lie on the tops of mountains, or in the basins of deserts, or on the rocky spines of the northern spruce belt, to which areas relatively few of the citizenry have, until now, demanded permanent access.

For the great past and future gifts of the traditional conservation concept we should all be profoundly grateful. We should also be vigilant, for the fences are erected by men, who are equally capable of removing them, after exercise of their best judgment.

Nevertheless it is probably true that the exemplary value of the great parks will obtain only as long as there is some recognizable relationship between the landscape inside the fence and that outside. When this relationship is no longer visible, or remembered, honest men will storm the parks and collect its specimens as exotic souvenirs, as we do the cult objects of forgotten religions.

Thus even to preserve our national parks we must learn to use naturally the land that lies outside their boundaries. It is not likely that we will manage this as long as we consider ourselves nature's natural enemies. As a step in the right direction, we might try to think of ourselves not as rapists of the landscape, but as its clumsy and naive lovers.

In this self-conciliatory spirit, what, if anything, can be said in defense of the sprawling non-towns that suddenly cover so much of what was recently our beautiful countryside? It is well known that these recent settlements do not compare favorably, by any known aesthetic standard, with Positano, for example, or Stockbridge, Mass., or for that matter with any ordinary American farm town before World War II. Nevertheless a man of objectivity, intelligence, and good will might conceivably find even in this chaff the seeds of new virtues, as yet unlabelled. Or, alternatively, to the degree that the alleged objectivity might really be a traditional Yankee contrariness—the other side of the perverse Thoreauvian coin—such a man might actually prefer to discover a suggestion of hope right in the middle of God's Own Junkyard than in the places where he has been told to look. We should also keep in mind the artist's close affinity to the magician, and the pleasure he takes in making silk purses out of sows' ears.

But whether out of a sense of fairness, a taste for argument, or a love of magic, Robert Adams has in this book done a strange and unsettling thing. He has, without actually lying, discovered in these dumb and artless agglomerations of boring buildings the suggestion of redeeming virtue. He has made them look not beautiful but important, as the relics of an ancient civilization look important. He has even made them look, in an unsparing way, natural.

Adams's pictures describe with precision and fastidious justice some of the mortal and venial sins that we have committed against our land in recent decades. The gaggle of plywood ranch houses at the foot of the mountain, fenced in by the trailer parks, acid neon, and extruded plastic of the highway, is an affront even to our modest expectations. But his pictures also show us that these settlements express human aspirations, and that they are therefore not uninteresting. It is clear also that these places are very casually built, and will therefore acquire

character soon enough. Amateur carpenters, willful repairmen, and the fearful climate will add a sort of architectural variety. And as Adams says, the sun shines on these works also, even if not quite so brightly as it did.

Adams's pictures are so civilized, temperate, and exact, eschewing hyperbole, theatrical gestures, moral postures, and *espressivo* effects generally, that some viewers might find them dull. There is probably nothing that can be done about this. It is not even certain that anything should be done about it, since the measured Attic view of things is not intrinsically better than the romantic. But other viewers, for whom the shrill rodomontade of conventional conservation dialectics has lost its persuasive power, may find in these pictures nourishment, surprise, instruction, clarification, challenge, and perhaps hope.

Though Robert Adams's book assumes no moral postures, it does have a moral. Its moral is that the landscape is, for us, the place we live. If we have used it badly, we cannot therefore scorn it, without scorning ourselves. If we have abused it, broken its health, and erected upon it memorials to our ignorance, it is still our place, and before we can proceed we must learn to love it. As Job perhaps began again by learning to love his ash pit.

John Szarkowski
Director, Department of Photography
The Museum of Modern Art

Introduction

The first uplift of the Rocky Mountains, the Front Range, revealed to nineteenth century pioneers the grandeur of the American West, and established the problem of how to respond to it. Nearly everyone thought the geography amazing; Pike described it in 1806 as "sublime," and Kathryn Lee Bates eventually wrote "America the Beautiful" from the top of the peak he discovered. Nonetheless, as a practical matter most people hoped to alter and exploit the region.

The mountains still synopsize the frontier, though our expectations have matured and the significance of the land has therefore changed—we want to live with it harmoniously. This may seem a tame goal when compared to that of our forebears, but in fact the struggle is desperate because it is also to live with ourselves, against our own creation, the city, and the disgust and nihilism it breeds.

Many have asked, pointing incredulously toward a sweep of tract homes and billboards, why picture *that*? The question sounds simple, but it implies a difficult issue—why open our eyes anywhere but in undamaged places like national parks?

One reason is, of course, that we do not live in parks, that we need to improve things at home, and that to do it we have to see the facts without blinking. We need to watch, for example, as an old woman, alone, is forced to carry her groceries in August heat over a fifty acre parking lot; then we know, safe from the comforting lies of profiteers, that we must begin again. Arthur Dove, the painter, was right:

We have not yet made shoes that fit
 like sand
Nor clothes that fit like water
Nor thoughts that fit like air
There is much to be done

Paradoxically, however, we also need to see the whole geography, natural and man-made, to experience a peace; all land, no matter what has happened to it, has over it a grace, an absolutely persistent beauty.

The subject of these pictures is, in this sense, not tract homes or freeways but the source of all Form, light. The Front Range is astonishing because it is overspread with light of such richness that banality is impossible. Even subdivisions, which we hate for the obscenity of the speculator's greed, are at certain times of day transformed to a dry, cold brilliance.

Towns, many now suggest, are intrusions on sacred landscapes, and who can deny it, looking at the squalor we have laid across America? But even as we see the harm of our work and determine to correct it, we also see that nothing *can*, in the last analysis, intrude. Nothing permanently diminishes the affirmation of the sun. Pictures remind us of this, so that we are able to say with the poet Theodore Roethke, "Be with me, Whitman, maker of catalogues: For the world invades me again."

The New West

Prairie

The outlying plains are still verdant, with ranges of grass to scan, and infrequent but lovely trees by which to measure space. Nearer the mountains and cities, however, these give way.

Farm road and cottonwood. South of Raymer.

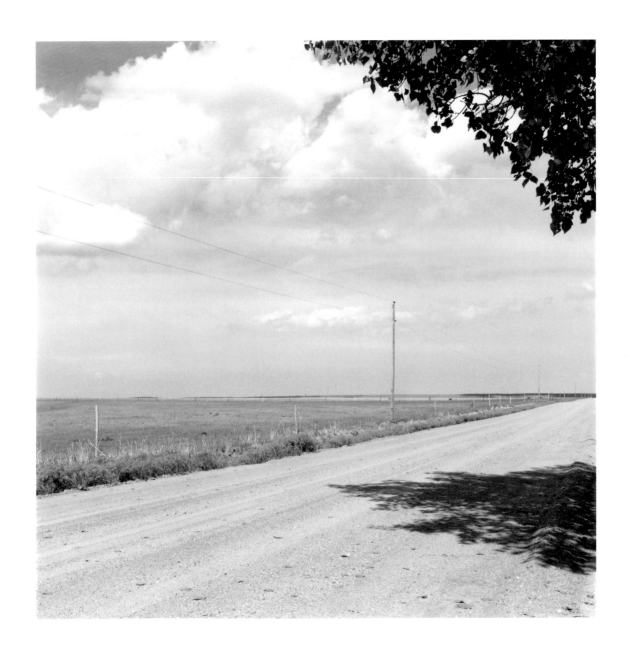

Grazing land with pines. Near Falcon.

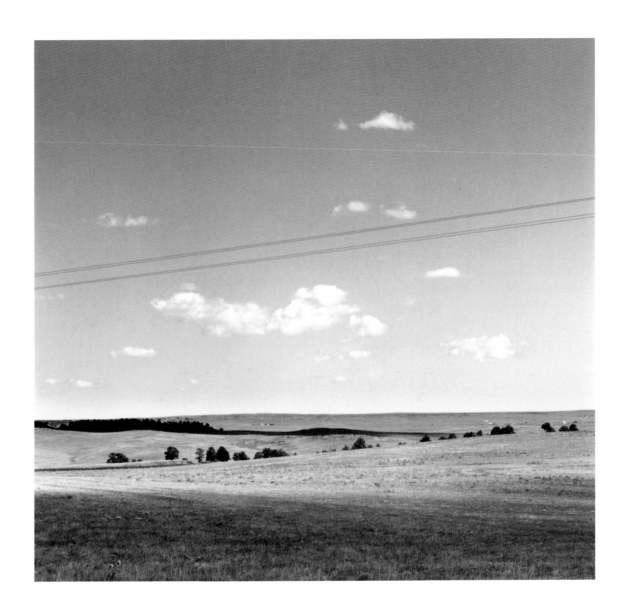

Along Interstate 25.

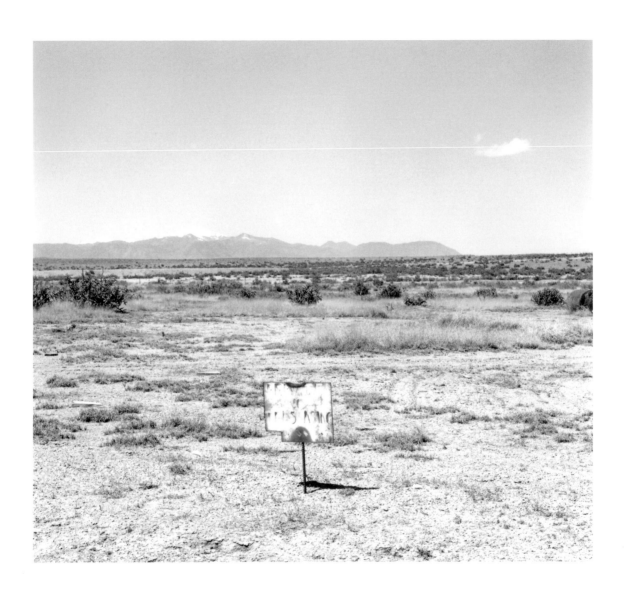

Along Interstate 25.

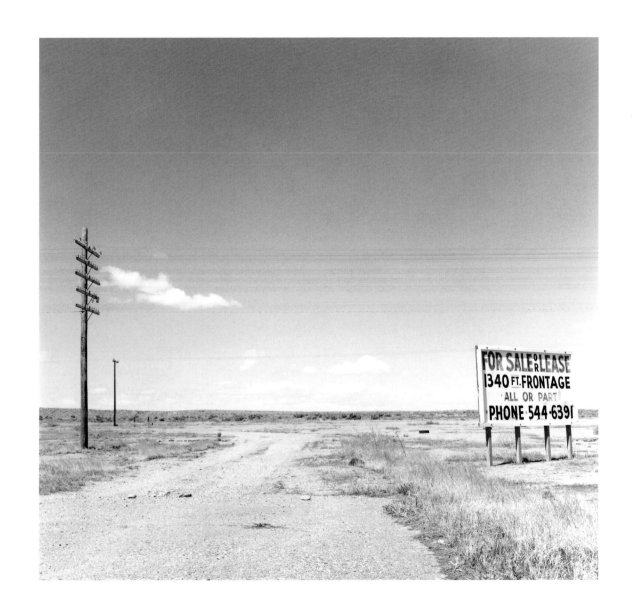

On Interstate 25.

Along Interstate 25.

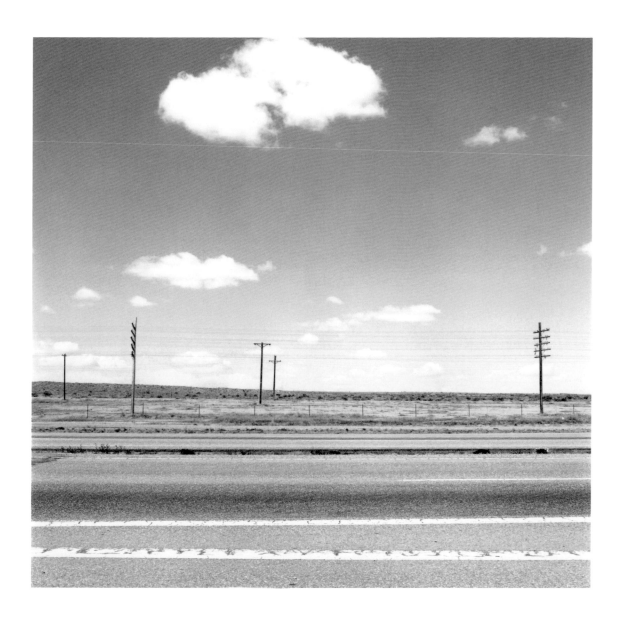

Along Interstate 25.

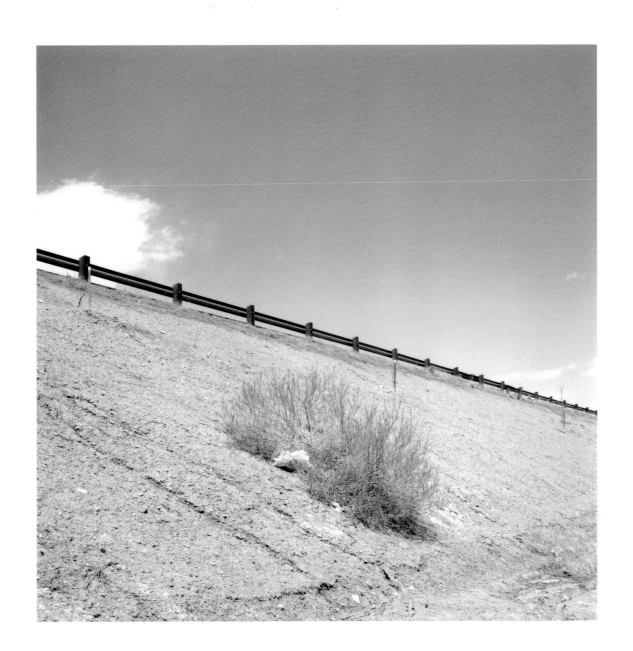

Along Interstate 25.

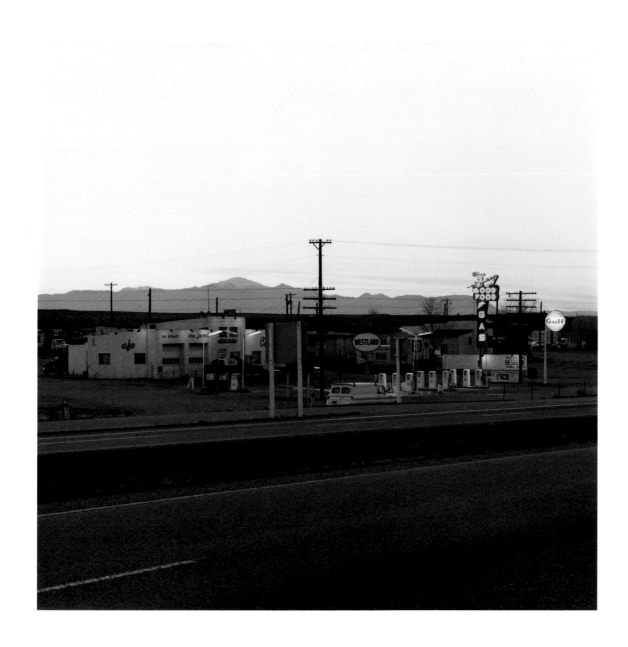

Pikes Peak, Colorado Springs, and the highway from the prairie.

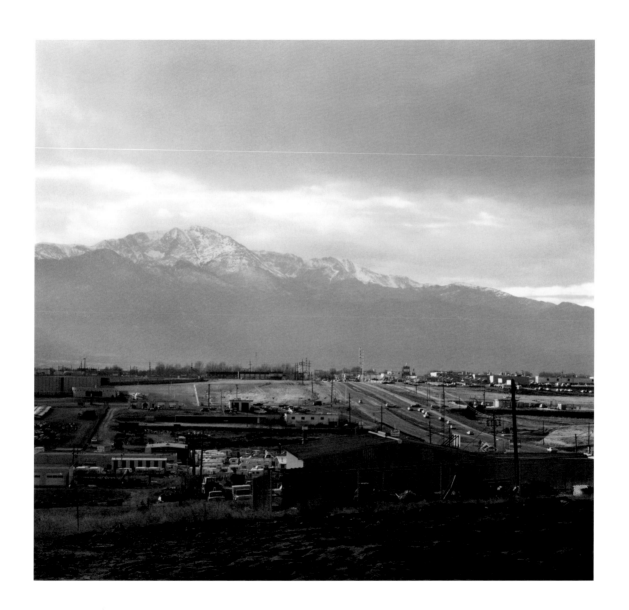

Tracts and Mobile Homes

A strip city, largely suburban, is evolving along the Front Range from Wyoming to New Mexico. Development has been anarchic, building is monotonous, and life inside is frozen by anonymity and loneliness.

Few of the new houses will stand in fifty years; linoleum buckles on counter tops, and unseasoned lumber twists walls out of plumb before the first occupants arrive.

Visible out picture windows, however, are fragments of open sky and long views that obscurely make radiant even what frightens us.

Basement for a tract house. Colorado Springs.

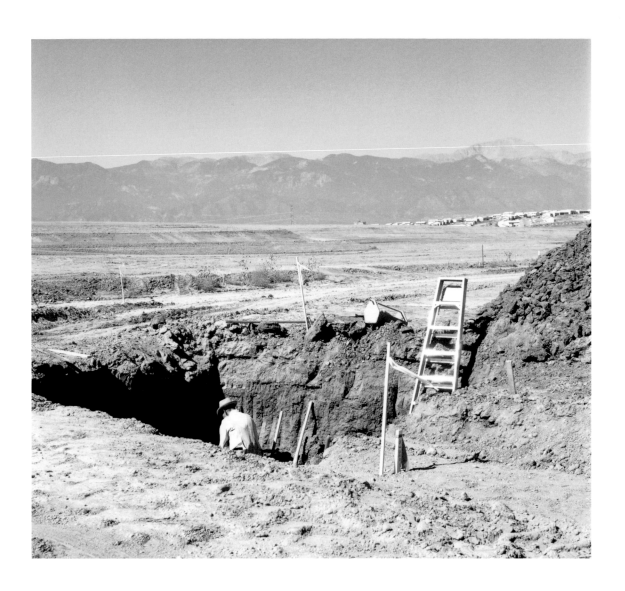

Frame for a tract house. Colorado Springs.

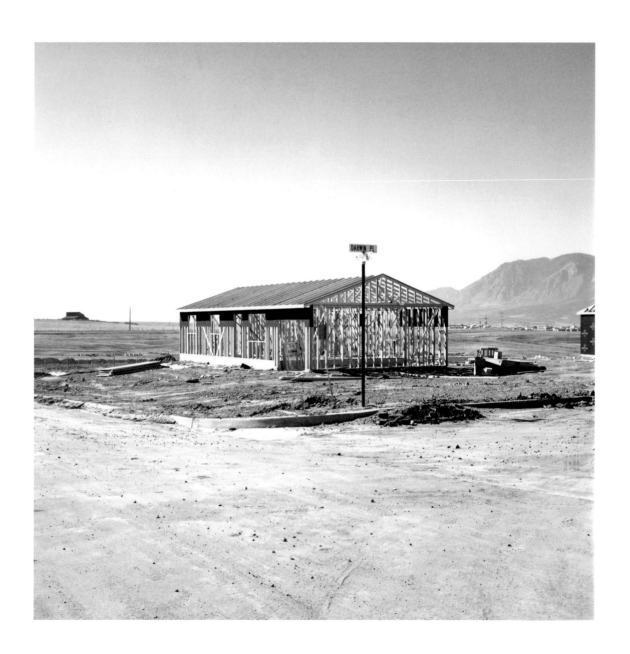

Newly completed tract house. Colorado Springs.

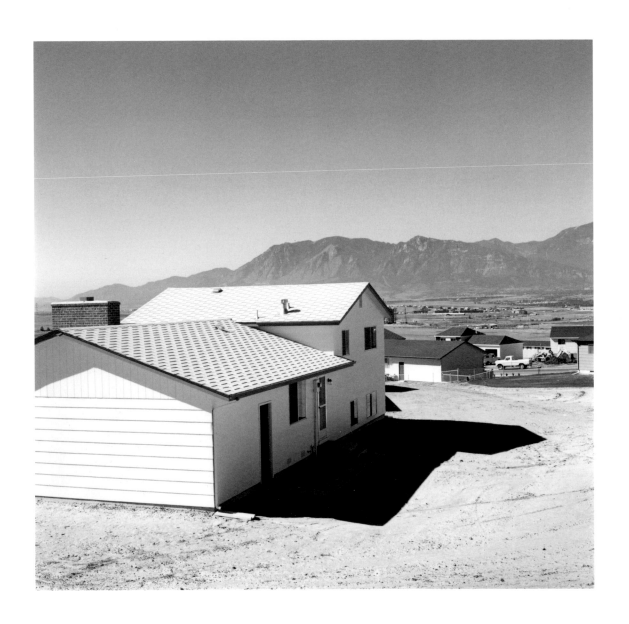

Newly occupied tract houses. Colorado Springs.

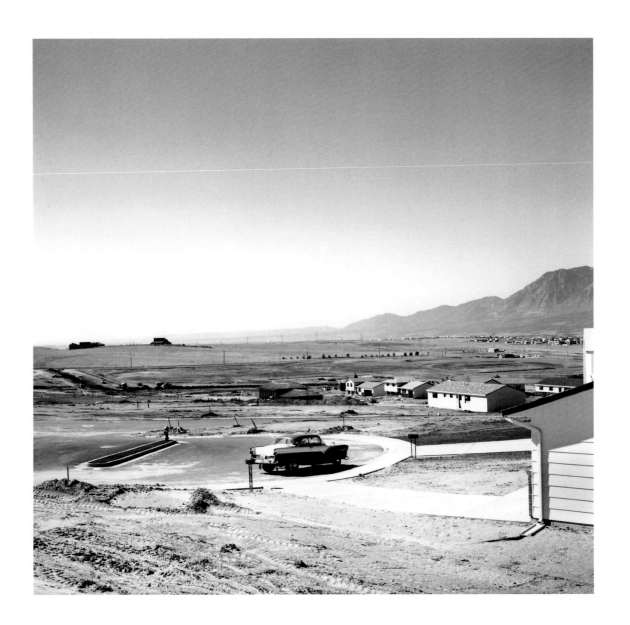

New subdivisions. Arvada.

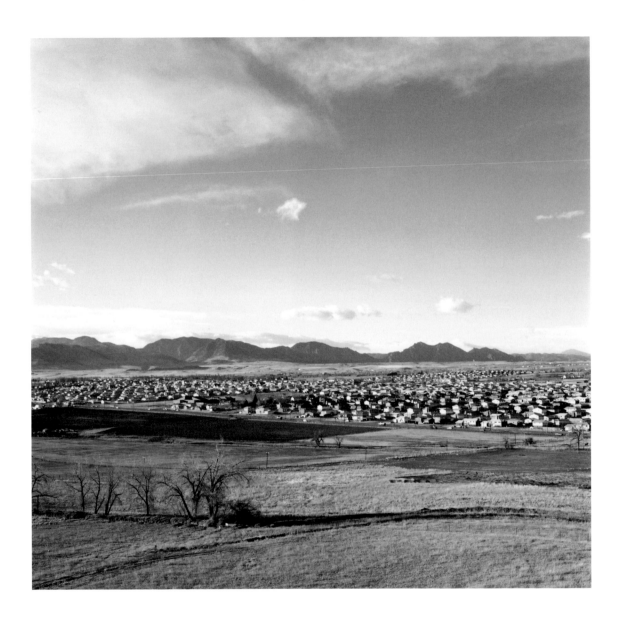

Tract house and outdoor theater. Colorado Springs.

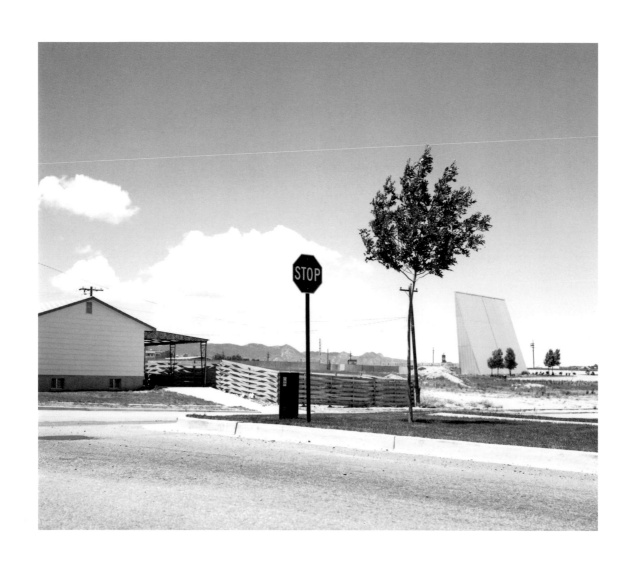

Jefferson County.

36

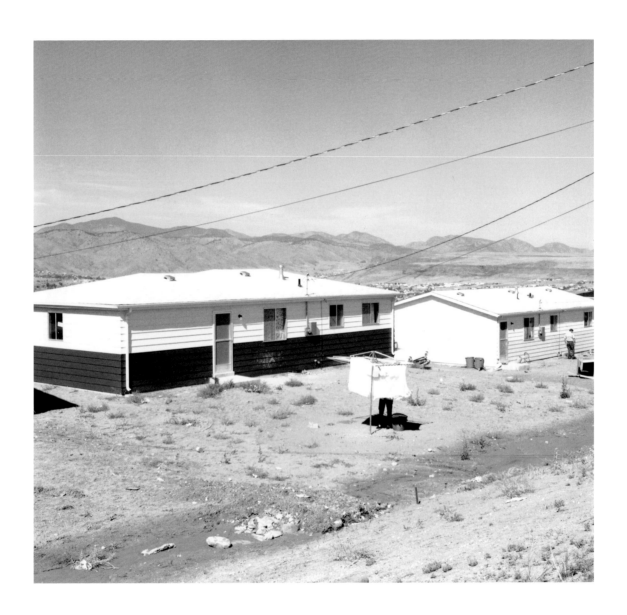

Pikes Peak Park, Colorado Springs.

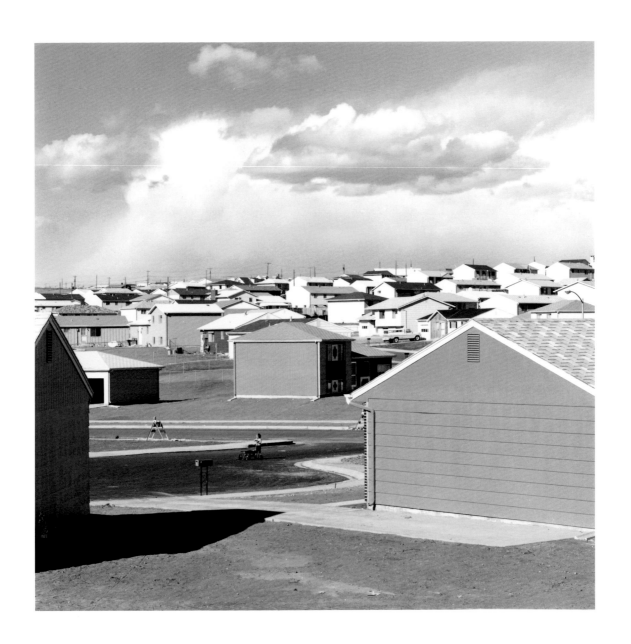

Colorado Springs.

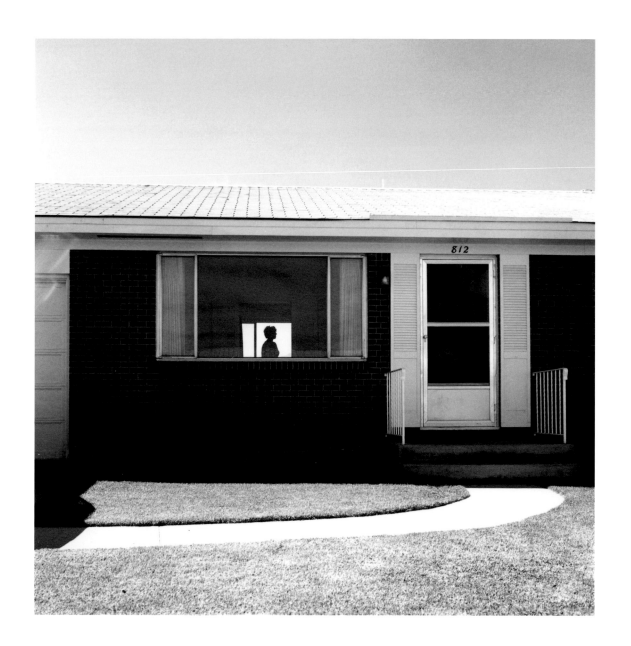

Out a front window. Longmont.

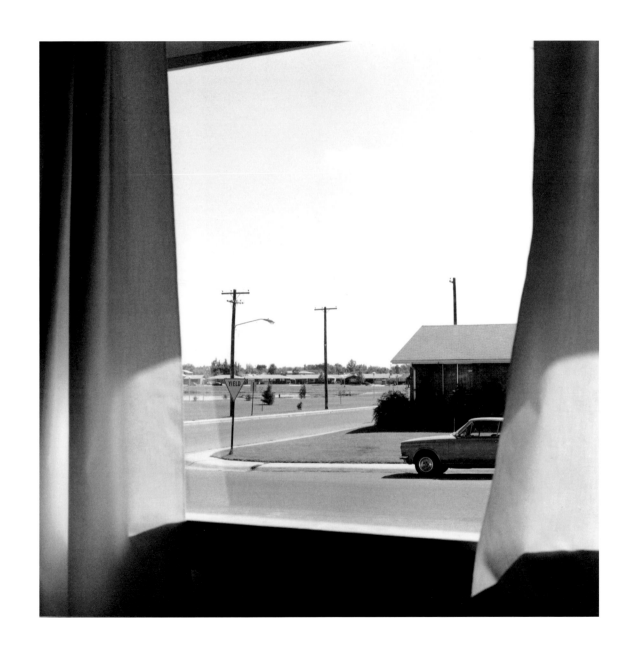

Colorado Springs.

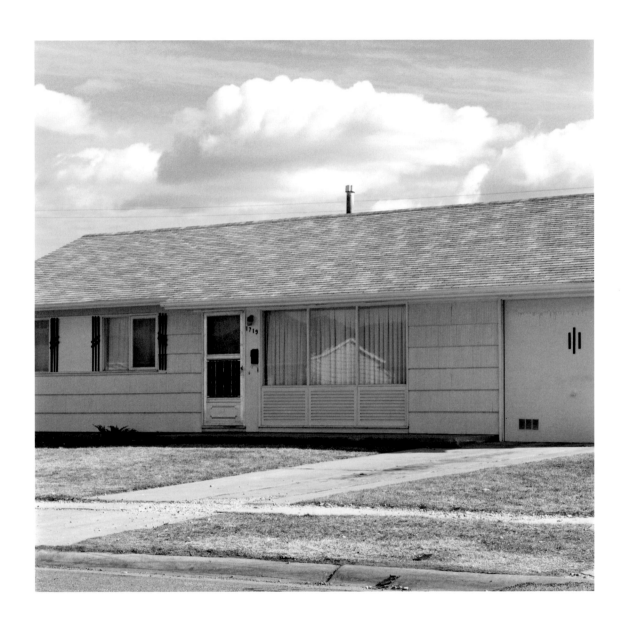

Colorado Springs.

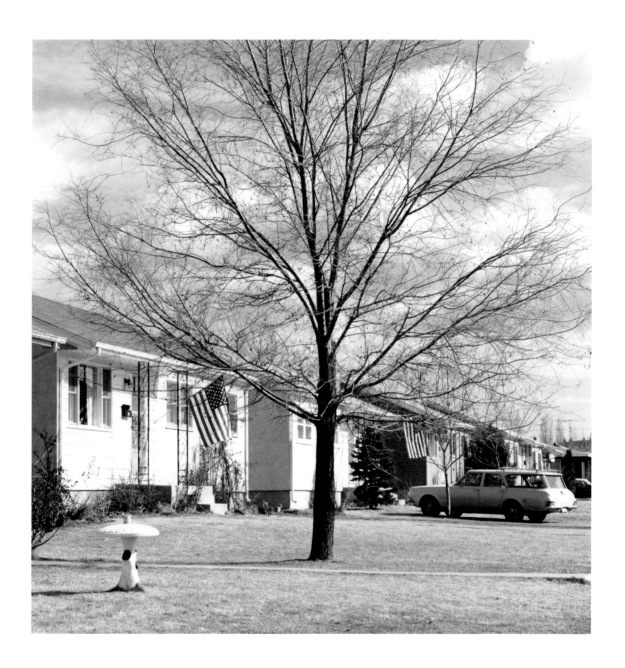

New subdivisions. Arvada.

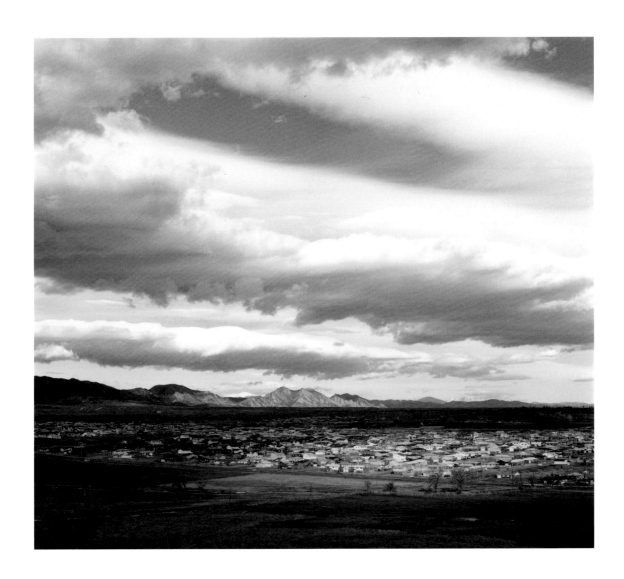

Colorado Springs.

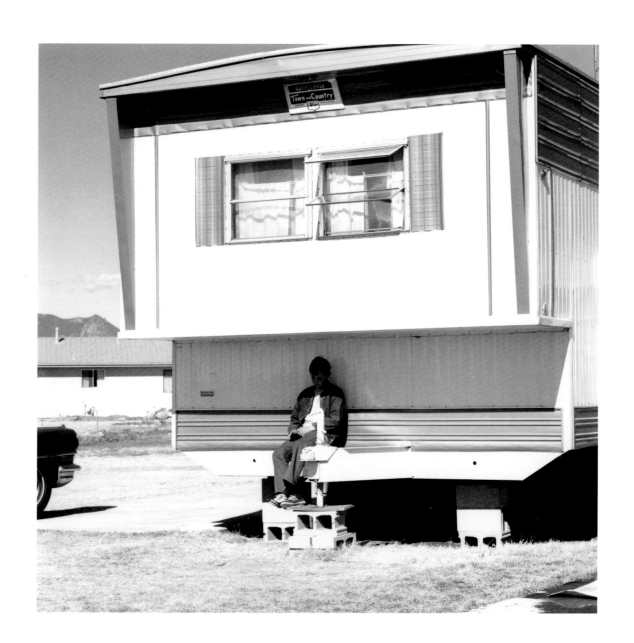

Colorado Springs.

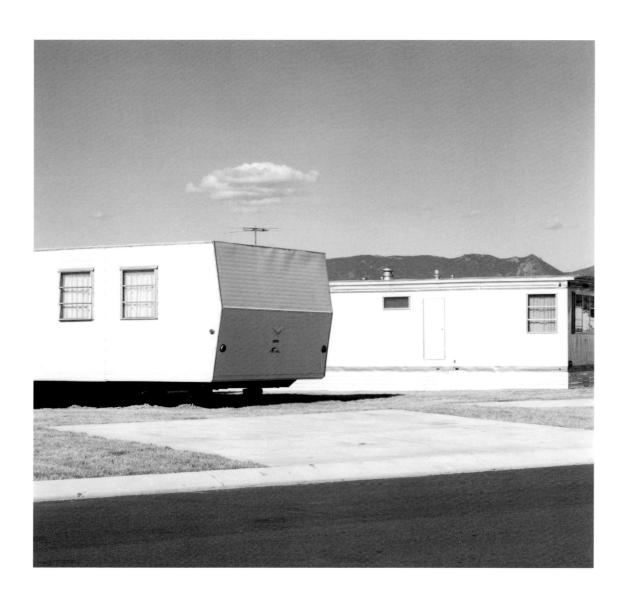

Sunday school. A church in a new tract. Colorado Springs.

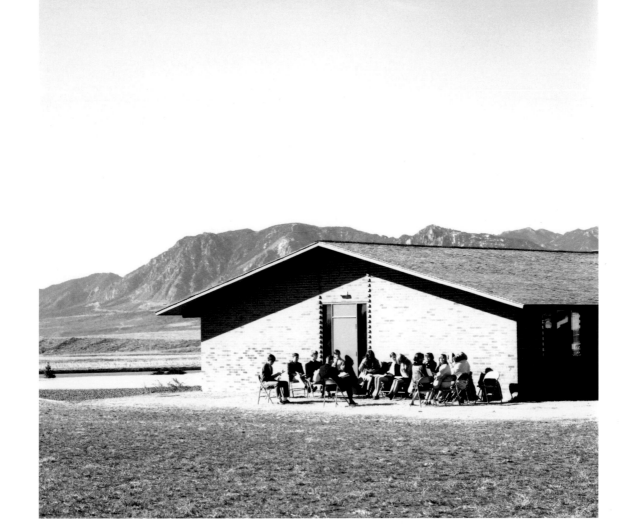

The center of Denver, ten miles distant.

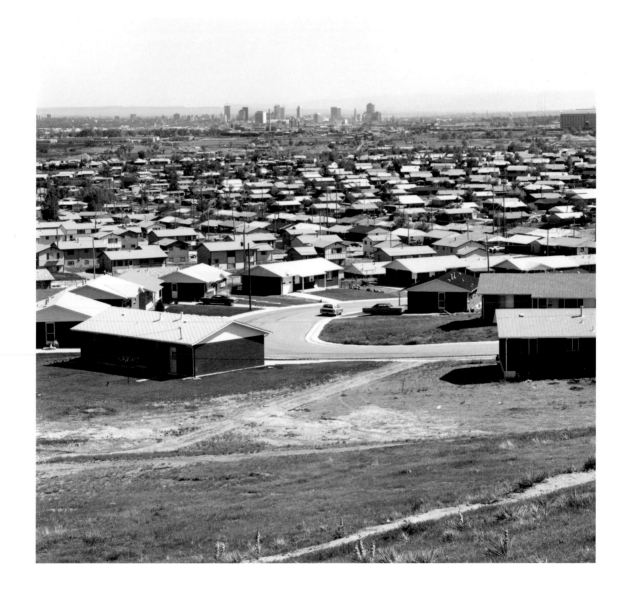

Real estate sign. Dusk. Colorado Springs.

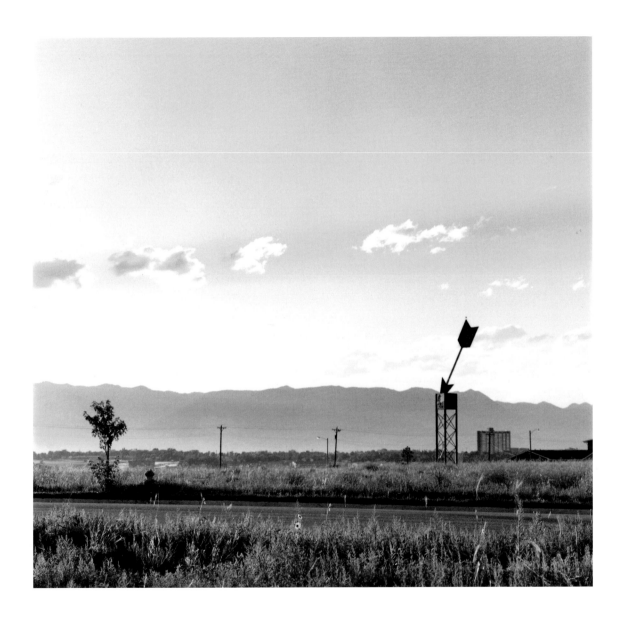

Tract house. Colorado Springs.

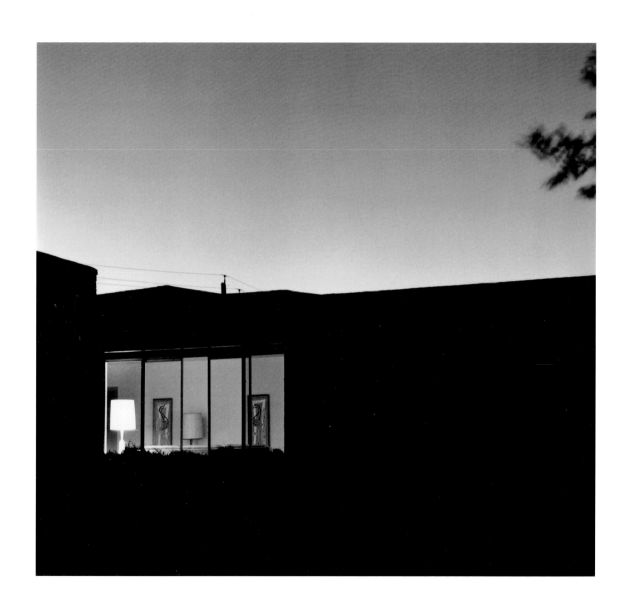

The City

Here no expediency is forbidden. A new house is bulldozed to make room for a trailer agency; sidewalks are lost when the street is widened; shrubs die in the smog and are replaced with gravel. Read the eschatological chaos of signs.

Colfax Avenue, Lakewood.

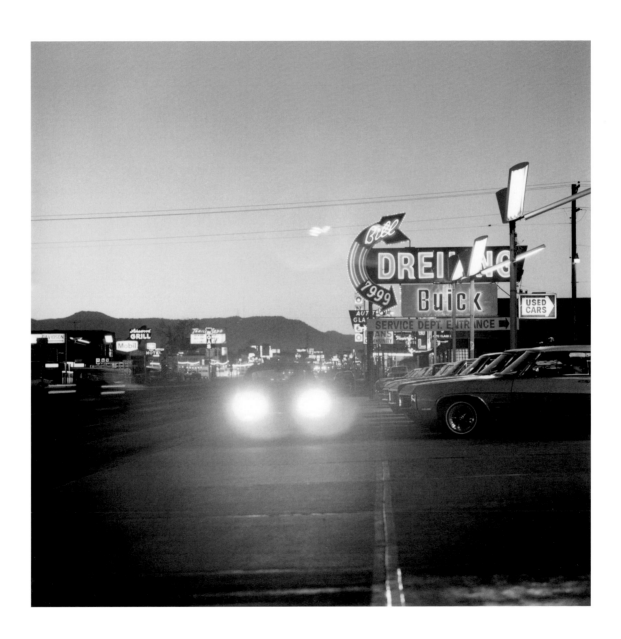

Nevada Avenue, Colorado Springs.

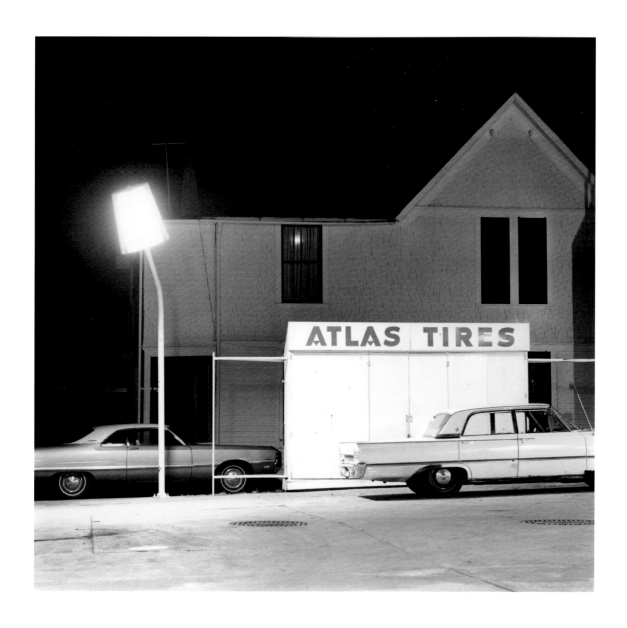

Sheridan Boulevard, Lakewood.

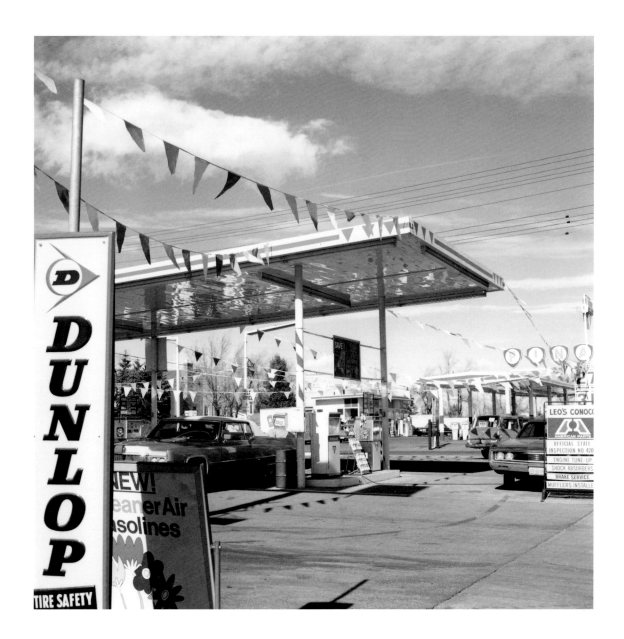

Sheridan Boulevard, Lakewood.

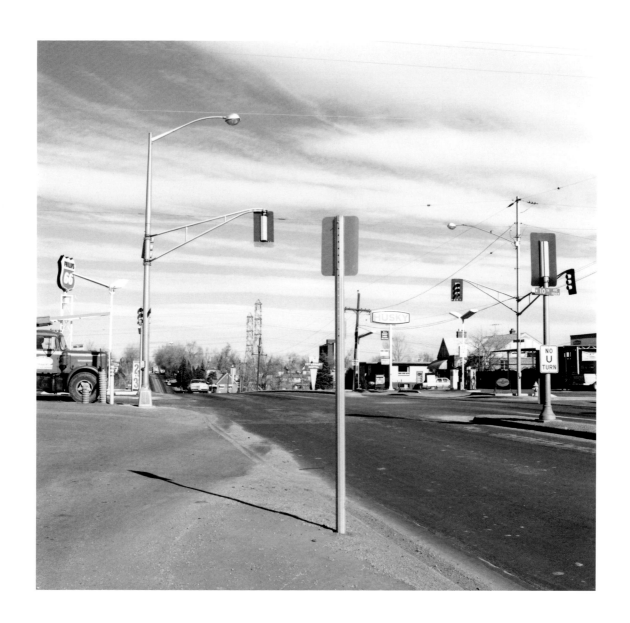

Alameda Avenue, Denver.

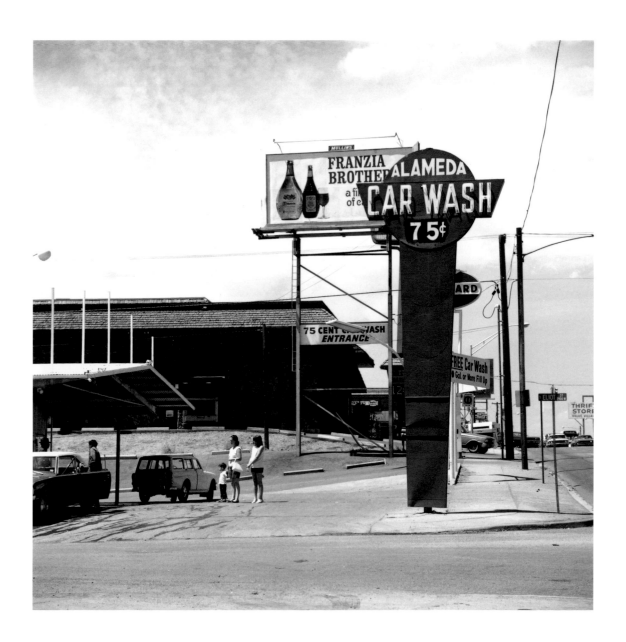

Church. Wadsworth Boulevard, Wheat Ridge.

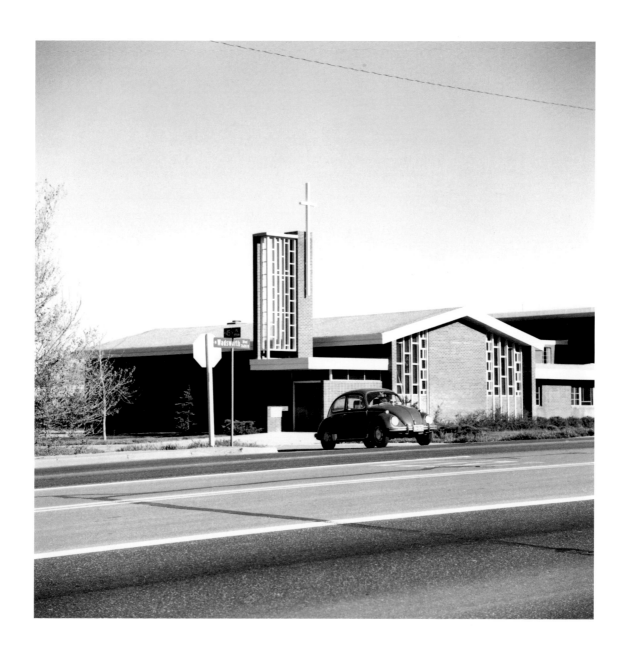

Federal Boulevard, Denver.

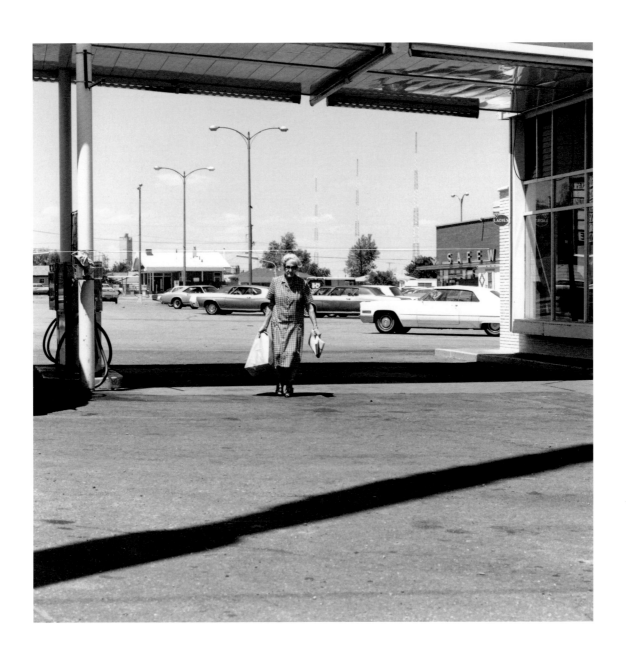

Curtis Street, Denver.

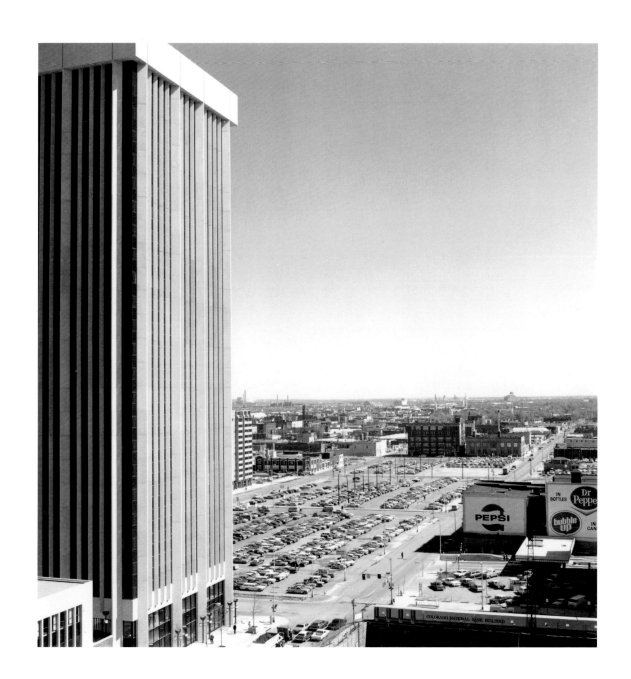

Alameda Avenue, Denver.

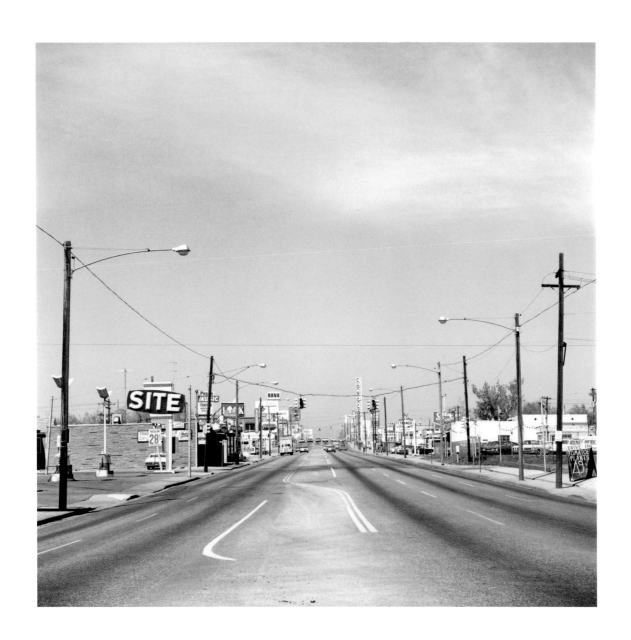

15th Street, Denver.

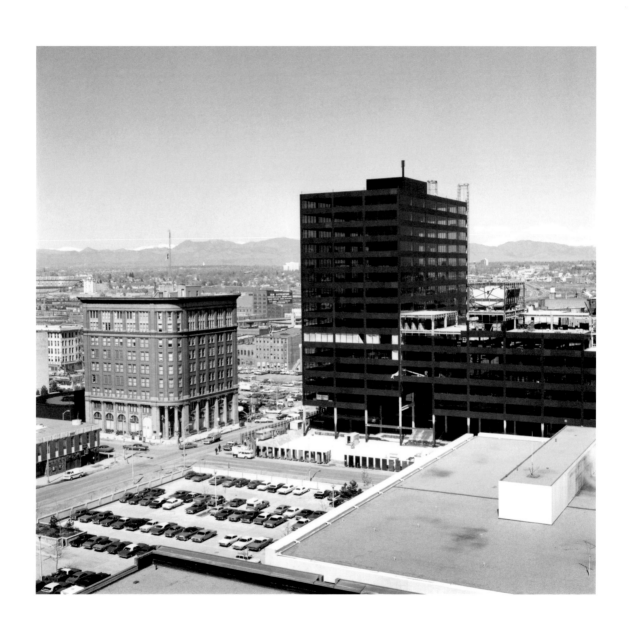

Drugstore. Lakeside.

The center of Denver, four miles distant.

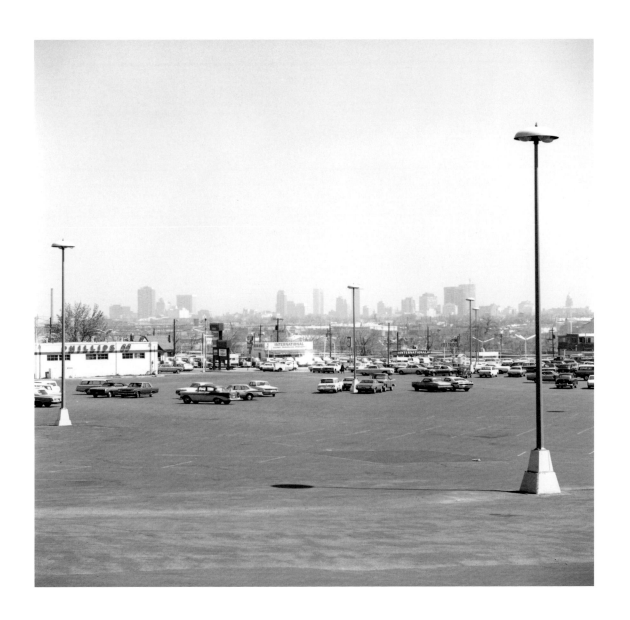

Foothills

Windswept, stony, and bright, the foothills are sometimes a last stop for travelers before they leave the plains on their way west. As if to deepen reflection, we have scattered through the mesas and ridges a thin clutter—an imitation cliff dwelling, an atomic bomb plant, monuments to Buffalo Bill and Will Rogers . . .

Outdoor theater and Cheyenne Mountain.

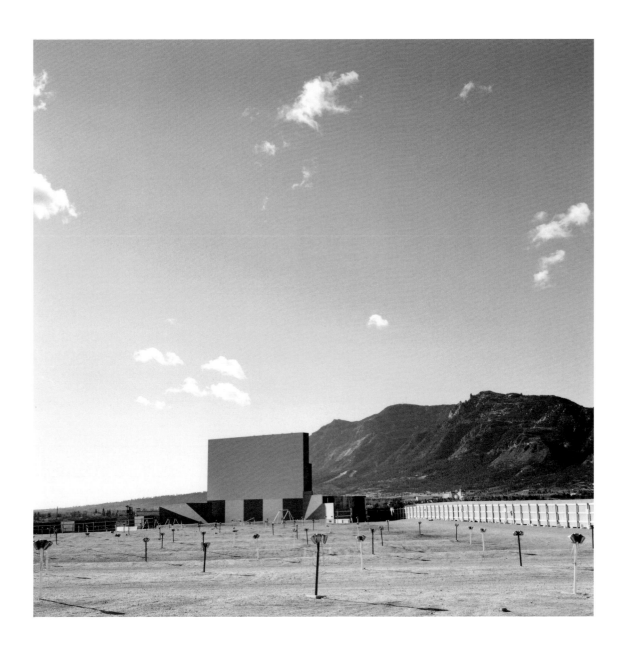

Golden.

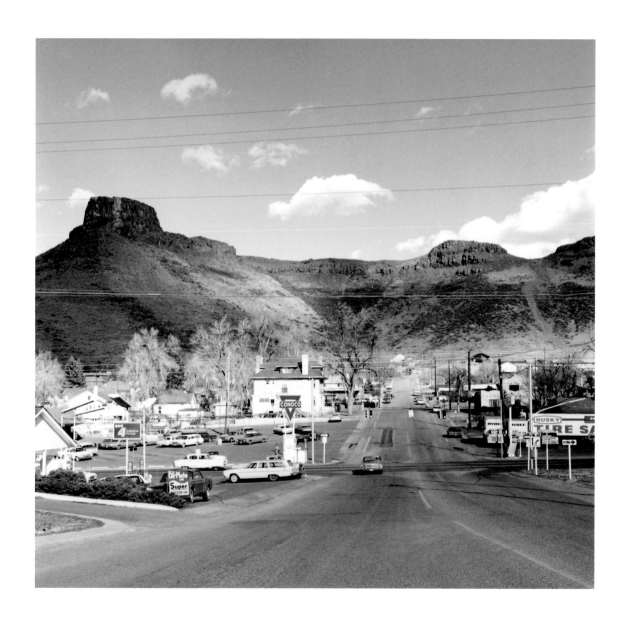

Colorado Springs.

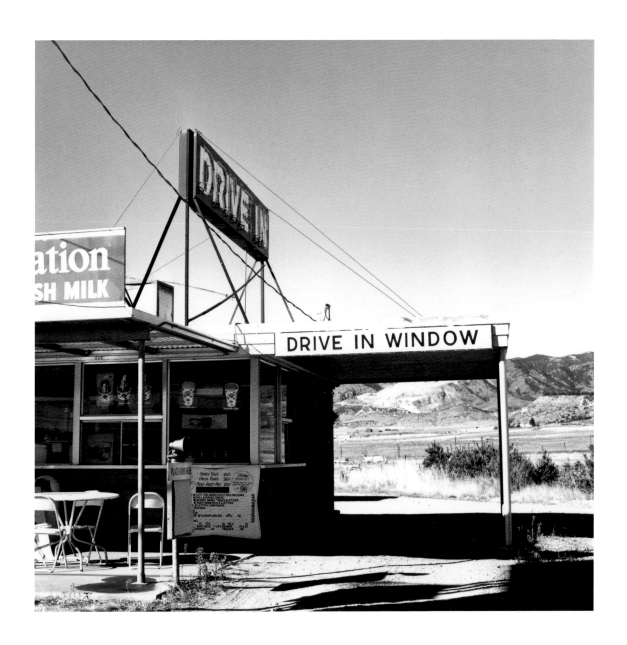

Buffalo for sale.

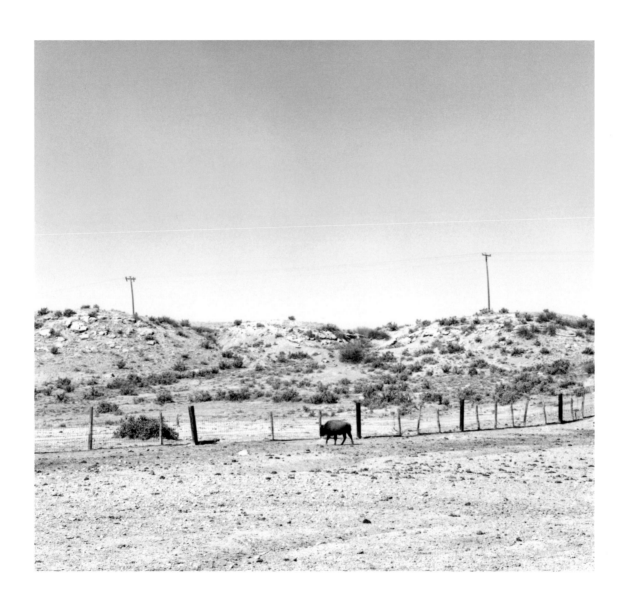

Motel.

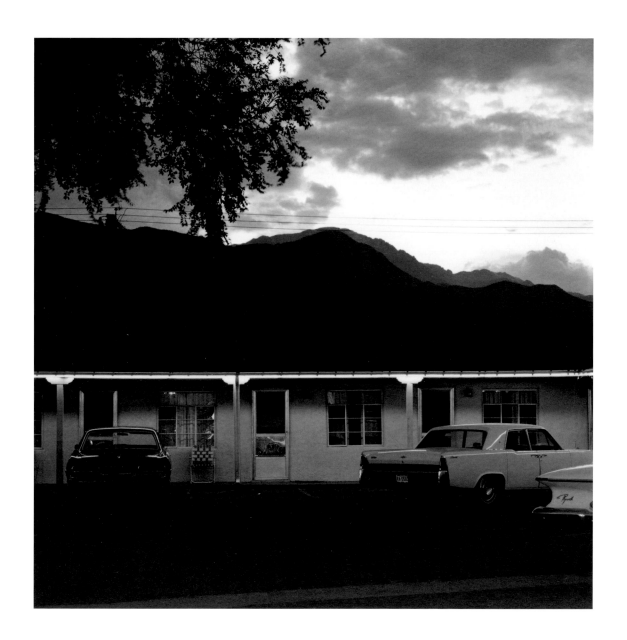

From Lookout Mountain.

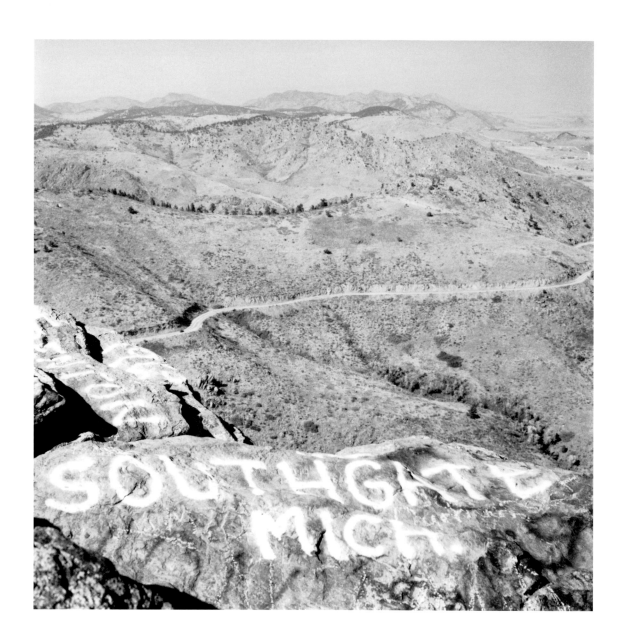

Green Mountain.

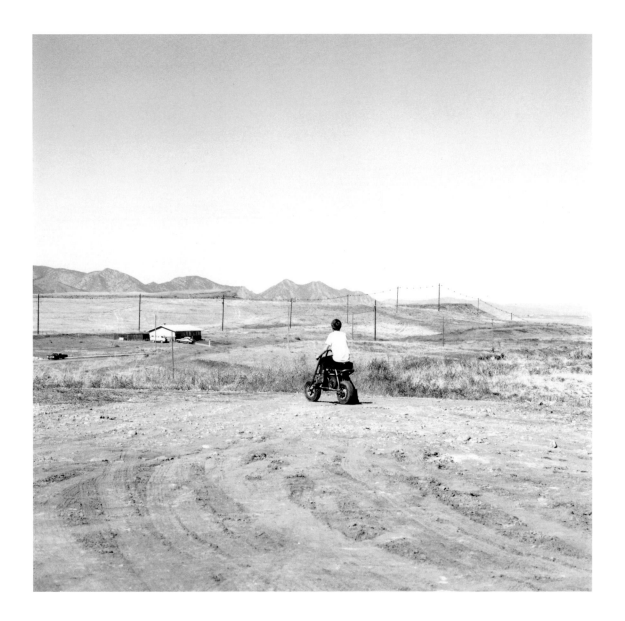

Pikes Peak.

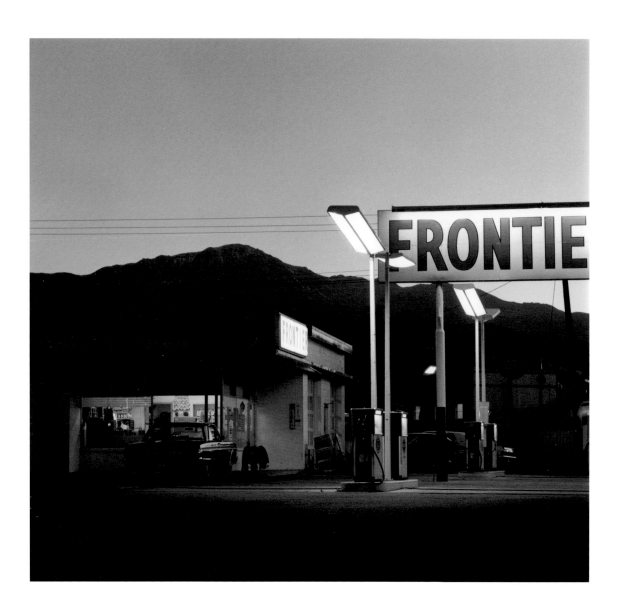

From Lookout Mountain.

Federal 40. Mount Vernon Canyon.

108

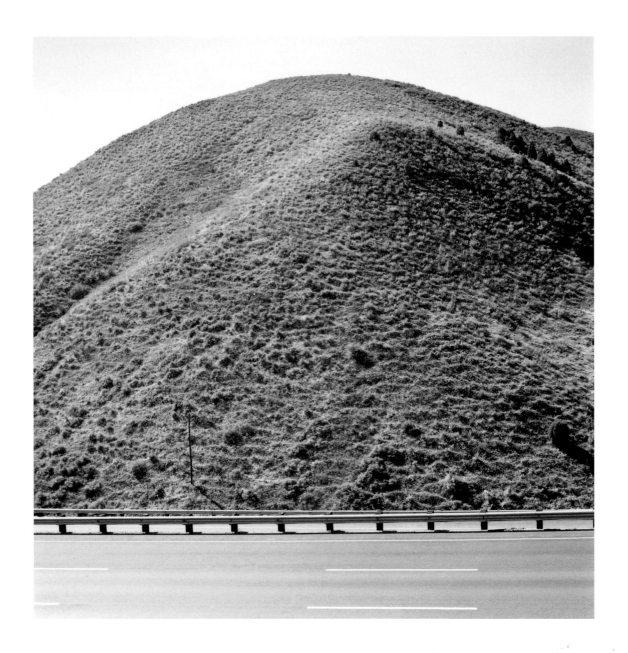

Entrance, Clear Creek Canyon.

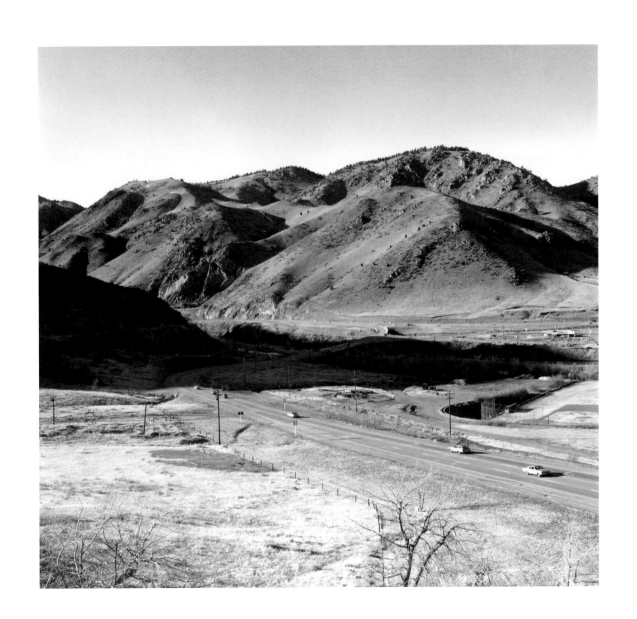

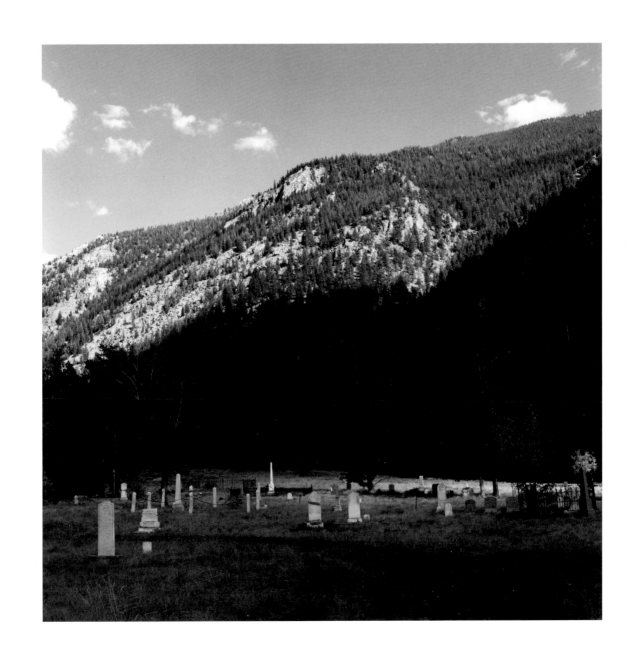

Grateful acknowledgement is extended to the National Endowment for the Arts for a fellowship that made possible the completion of the book.

I am indebted to the following for permission to reproduce copyrighted material: Harcourt Brace Jovanovich, Inc., publishers of The Poems Of Richard Wilbur, *containing the poem "Junk"; the regents of the University of California, publishers through the University of California Press of* Arthur G. Dove *by Frederick S. Wight, containing Dove's poem "A Way To Look At Things"; Doubleday & Co., Inc., publishers of* The Collected Poems of Theodore Roethke, *containing the poem "The Abyss"; Cooper Square Publishers, Inc., publishers of* Time Exposure *by William Henry Jackson.* —Robert Adams, 1974

The New West was originally published in 1974 by Colorado Associated University Press under the direction of John Schwartz. The reproductions in this edition were made from original prints from Robert Adams's master sets, which reside at the Yale University Art Gallery, New Haven, Connecticut.

Project Editor (2008): Michael Famighetti
Production (2008): Sarah Henry

The staff for this book at Aperture Foundation includes:

Michael Culoso, *Director of Finance and Administration*; Lesley A. Martin, *Publisher, Books*; Susan Ciccotti, *Managing Editor, Books*; Yass Etemadi, *Editorial Assistant*; Matthew Pimm, *Production Director*; Andrea Smith, *Director of Communications*; Kristian Orozco, *Director of Sales and Foreign Rights*; Diana Edkins, *Director of Exhibitions and Limited-Edition Photographs*; Daisy Lumley, Sebastian Meija, Carmen Winant, *Work Scholars*

This project was made possible, in part, through the generosity of Lynne and Harold Honickman and Fraenkel Gallery, San Francisco.

Third edition
Printed by Trifolio, Verona, Italy
Separations by Thomas Palmer

10 9 8 7 6 5 4 3 2 1

Library of Congress Control Number: 2007935197
ISBN 978-1-59711-060-0

Aperture Foundation books are available in North America through:
D.A.P./Distributed Art Publishers, 155 Sixth Avenue, 2nd Floor, New York, N.Y. 10013
Phone: (212) 627-1999, Fax: (212) 627-9484

Aperture Foundation books are distributed outside North America by:
Thames & Hudson, 181A High Holborn, London WC1V 7QX, United Kingdom
Phone: + 44 20 7845 5000, Fax: + 44 20 7845 5055, Email: sales@thameshudson.co.uk

aperturefoundation 547 West 27th Street, New York, N.Y. 10001, www.aperture.org

The purpose of Aperture Foundation, a non-profit organization, is to advance photography in all its forms and to foster the exchange of ideas among audiences worldwide.